MY SAFARI BOOK

A CHILDREN'S GUIDE TO KENYA

Dr. Diana Prince

AuthorHouse™
1663 Liberty Drive
Bloomington, IN 47403
www.authorhouse.com
Phone: 833-262-8899

Because of the dynamic nature of the Internet, any web addresses or links contained in this book may have changed since publication and may no longer be valid. The views expressed in this work are solely those of the author and do not necessarily reflect the views of the publisher, and the publisher hereby disclaims any responsibility for them.

This book is printed on acid-free paper.

ISBN: 979-8-8230-1454-0 (sc)
ISBN: 979-8-8230-1535-6 (hc)
ISBN: 979-8-8230-1455-7 (e)

Library of Congress Control Number: 2023917457

Print information available on the last page.

Published by AuthorHouse 09/25/2023

authorHOUSE®

MY NAIROBI JOURNAL

The Animals of Kenya

1. Lioness with her Cub

Today was our first day on safari. I was very excited to see a mother lion near the river. She was protecting her cubs. We were all very quiet in our land rover, and did not intrude on her territory. She looked carefully around for any dangers.

A lioness will mature and give birth when she is about four years old. Normally, the average lion birth will produce three or four offspring. It is the mother who teaches her cubs how to hunt. In situations where another lion could pose a threat, the lioness will not hesitate to attack even a much larger male lion if her cub's safety is at stake.

In the lion community, the mothers work together to take care of their cubs. In some cases, one female will supervise the care of the cubs, while the other females are hunting together. It is a very co-operative effort.

It is interesting that some female lions will sometimes stay in their lion group, called a "pride", for their entire lives.

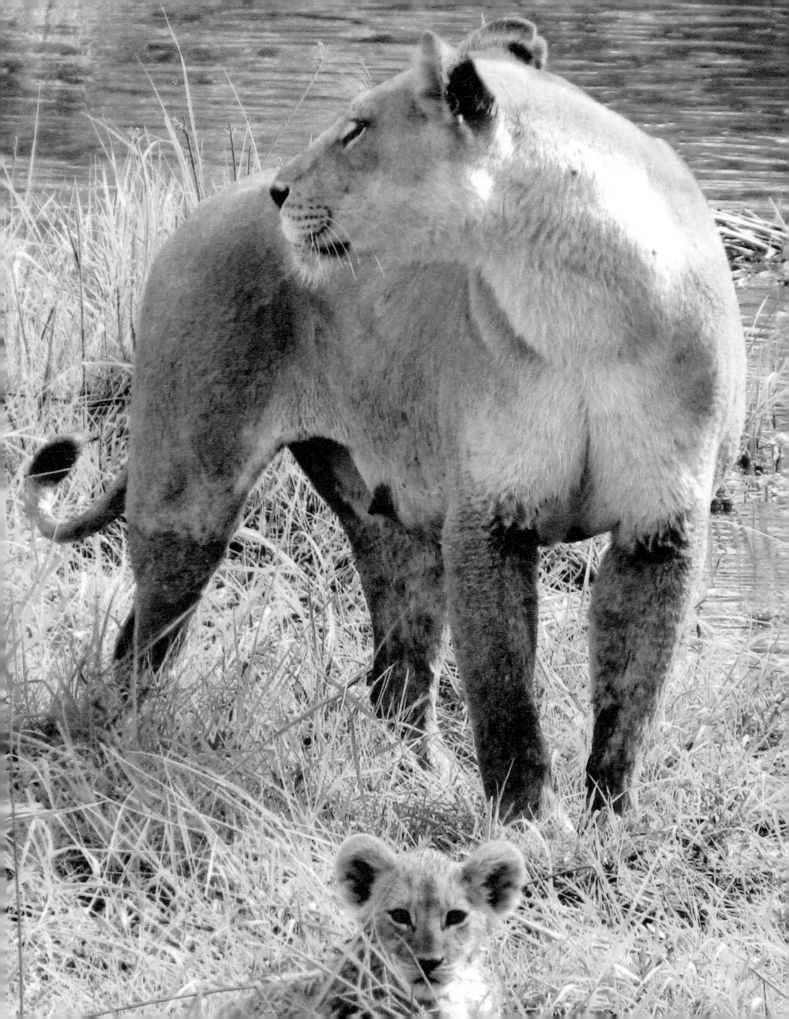

2. The Lioness as Hunter

Despite the greater physical strength of the male lion, it is the slender and smaller lionesses who usually take the primary role of hunting.

Because they are more lean and slender than their male counterparts, they are usually able to run more swiftly. They have been known to run over 40 miles per hour when they pursue and capture prey.

After years of being active in a lion group, the lioness is not abandoned at a mature age. In fact, she has an honored status in that social group, as the older lionesses are "respected elders", and have spent their lives providing food for the pride.

The lionesses have an alliance in that the older females are provided food by the younger females. Also the older lionesses will often be the caretakers of the younger lions, while their mothers actively hunt for food.

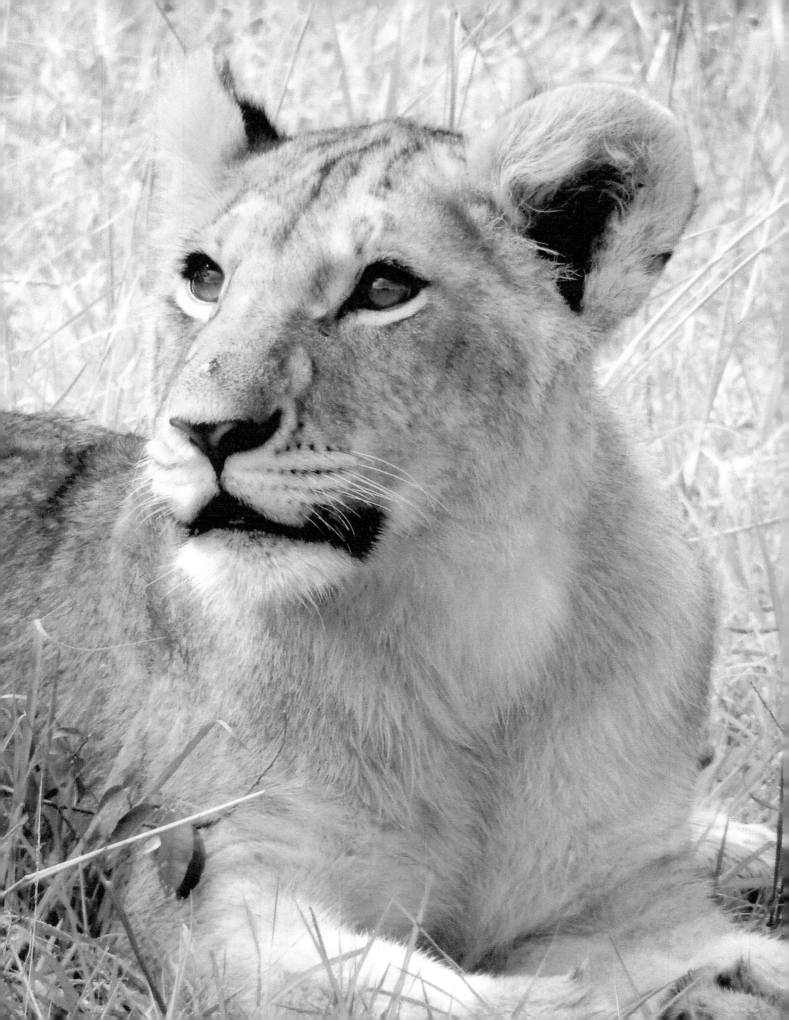

3. Male Lions in the Pride

At around two years of age, the male lion cubs reach maturity. At this age, they leave the group of lions known as a "pride", in which they have lived since birth.

This is a time for seeking out the new. As adults they will adopt a nomadic quest to "find their place." They will search out and attempt to join a new community of lions.

This is, in fact, a quest to find a new territory and a new base of power.

These lions will not hesitate to kill the males in an already established "pride" or community. These newcomers will fight to remove the older lions from power by running them off or, in some cases, even killing them.

The new lions will then take over mastery and control of their newly won territory. They will also claim alliances with the females who remain. Sometimes the lionesses from the former group will resist this assault on their communities, especially if any of their cubs have been killed by the newcomers.

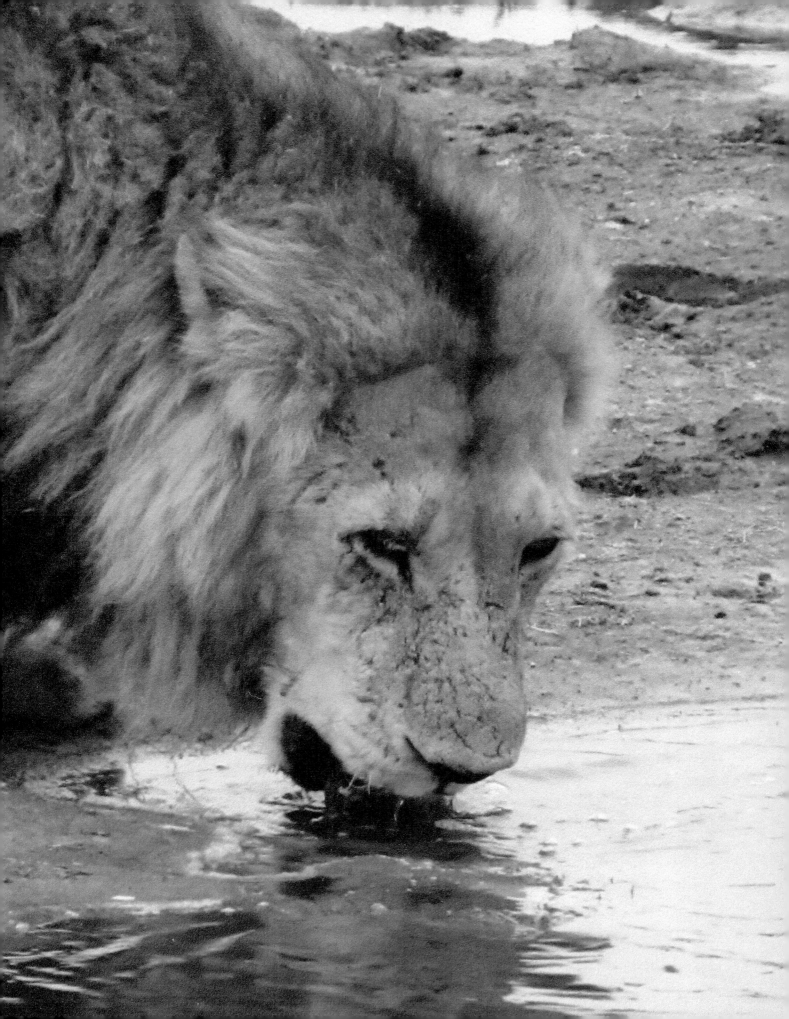

4. Lions and Dominance

Male lions in a group are referred to as a "pride". Over time, male lions will sometimes decide to take over another pride, of community of lions. In this event, they will fight the dominant—or primary males in that group.

If the invading lions succeed in defeating the dominant male in the new group, they will often kill any cubs who are still with their mother. This is to ensure that they will be the dominant and ruling males, after they have killed or banished the original powerful males.

This becomes a life and death fight for power and gaining new territory. After killing the males, and sometimes the young and dependent lion cubs, the newcomers will claim the females for themselves.

Basically, the male lions fight, as a group, against their rivals, to replace them. The outcome will determine who wins power. It is a contest for territory and power. Some lions are killed or driven out. The victorious lions take power.

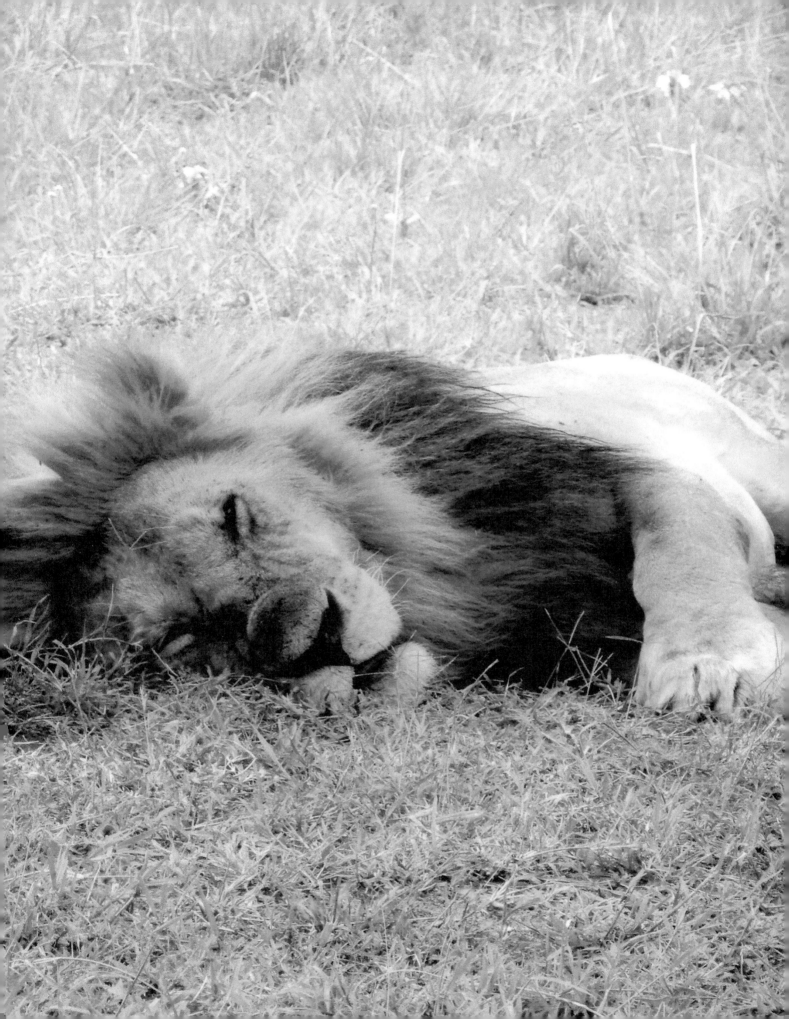

5. Lioness Carrying Cubs across Stream

Today we saw the mother lion carry her young cubs in her mouth to take them to safer and higher ground nearby.

The river water had risen too high for her small young cubs to navigate by themselves. To move them to higher ground, it was necessary to cross the deep water. She had to move them, one at a time.

The cubs were too young and small to cross this water by themselves. The only way for the mother lion to safely move the cubs across the dangerous water was to carry them across to the safer ground herself. She picked each one up, gently in her mouth. She then carried them—one by one—across the water very slowly and carefully.

All the time, she was aware of her surroundings. She was alert for any signs of danger.

She looked around, several times, as she carried her cubs to safety on the other side of the river. She did not rest until they were all safe.

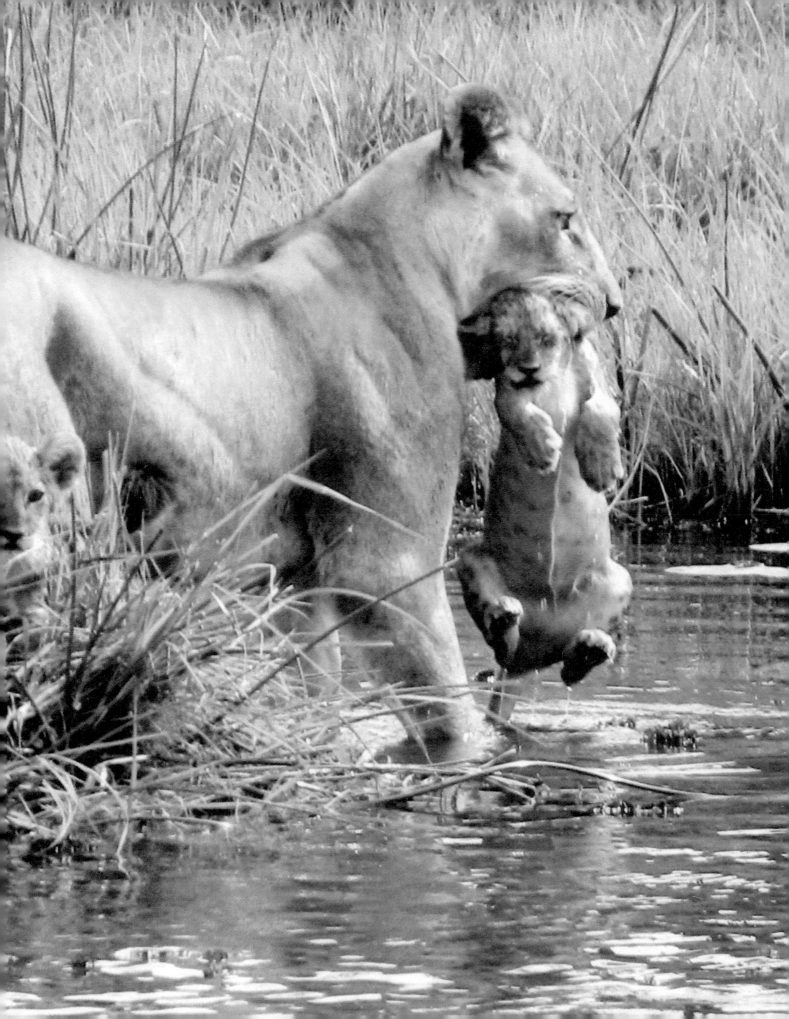

6. Vervet Monkey in Jungle

There are many varieties of monkeys in the Jungle. The monkey shown here is called a "Vervet Monkey." It is also known as "Hamlyn's Monkey". It is classified as an "Old World" monkey. The Vervet is native to Africa, and is very common in many parts of Kenya.

This monkey is recognizable by the white line that frames its face, and the thick brown fur around it. It is a medium-size monkey, and is very active during the day time.

Vervet Monkeys have a surprisingly diverse diet. In trees they eat nuts, leaves and seeds. On the ground, they find berries and other fruit. In a short visit to an untended garden, they will eat buds, flowers, weeds and grass.

The Vervet Monkey sleeps in trees, rather than on the ground. This provides protection against his predators. On occasion he will rob a bird's nest to eat the eggs. He will also catch small ground animals like mice and lizards.

This monkey can live up to 30 years.

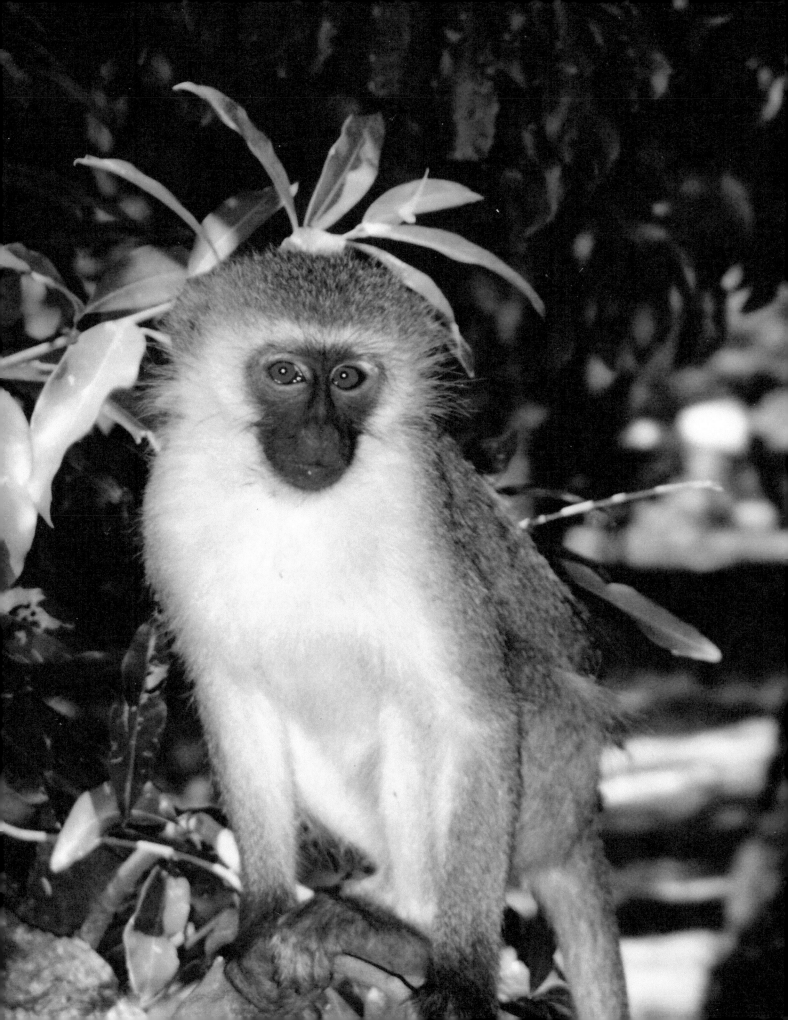

7. Monkeys in the Jungle

Although the Vervet Monkey is one of the most common species of African monkey, there are a total of 164 other African monkey species. Among these are such diverse monkeys as the Red Colobus, the Blue Monkey, and the Crowned Monkey.

The Red Colobus Monkey, for example, has a white and black face, but its body has a thick and distinctive coat of red thick fur. Within this family, there are almost 20 distinct types, half of which are considered as endangered species. Unlike other monkeys, the Red Colobus monkey will never eat meat. This monkey will only eat fruits, shrubs and flowers. It is also very rarely aggressive. The Red Colobus monkey occupies forests in several parts of Africa.

Orangutans are also common in Africa. They are considered the most intelligent of the monkeys. And one monkey called the "Blue Monkey" is actually a greenish brown, but its dark hairless face has a bluish hue from which it gets its name.

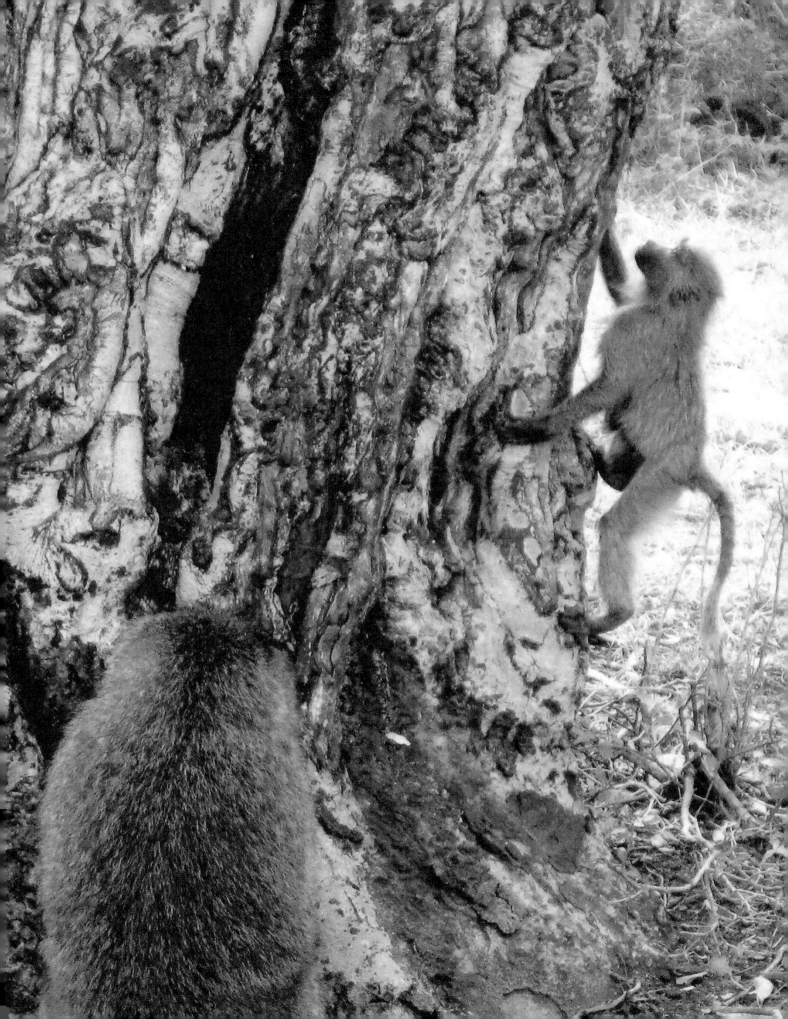

8. Smaller Monkeys

There are many smaller species of monkeys. Sometimes people try to raise them as pets. While some monkeys can make good pets, many do not adapt to being confined in small cages. However, in the right setting with adequate space, food and care, some monkey species can make excellent pets.

Chimpanzees can thrive when they have enough open space and temperate climates. They are very expensive and can cost thousands of dollars. They should have a spacious cage with climbing equipment, and often require special diets.

Spider Monkeys weigh about 25 pounds. Because they are so active, they need a large enclosure. They can live well over 30 years.

Capuchins are sometimes chosen as pets for disabled people. These monkeys are very intelligent, and weigh only about ten pounds. They can live up to 40 years.

Marmosets are among the world's smallest monkeys. They weigh about ten ounces, and are less than a foot in length.

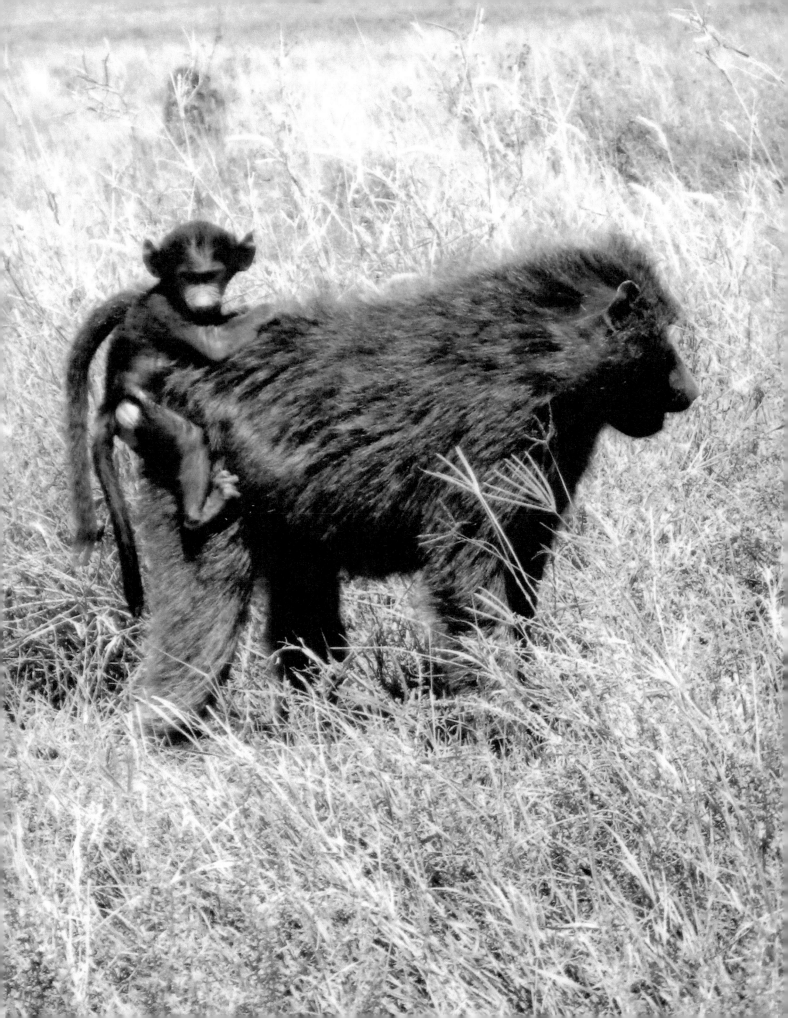

9. Inquisitive Giraffe

The giraffe is known as the "Reticulated Giraffe". It is also called the "Somali Giraffe". This animal is very common in the Samburu National Reserve in Kenya.

The giraffe has the distinction of being the tallest land animal on earth. Amazingly, new born giraffes are able to stand less than an hour after their birth. And even more surprising, they are able to run about 12 hours after they are born.

For almost 6 months, the new-born giraffes form groups together. While all giraffes have distinct markings, no two giraffes are identical in their markings. Each giraffe's pattern is as individual as human fingerprints.

They eat for about 16 hours a day. Most of their day is spent foraging for food. They are able to sleep for as few as 30 minutes in a 24-hour period.

Giraffes are also able to sleep standing up. And, even more surprising, they are able to give birth while they are standing.

The average life span of the giraffe is about 27 years.

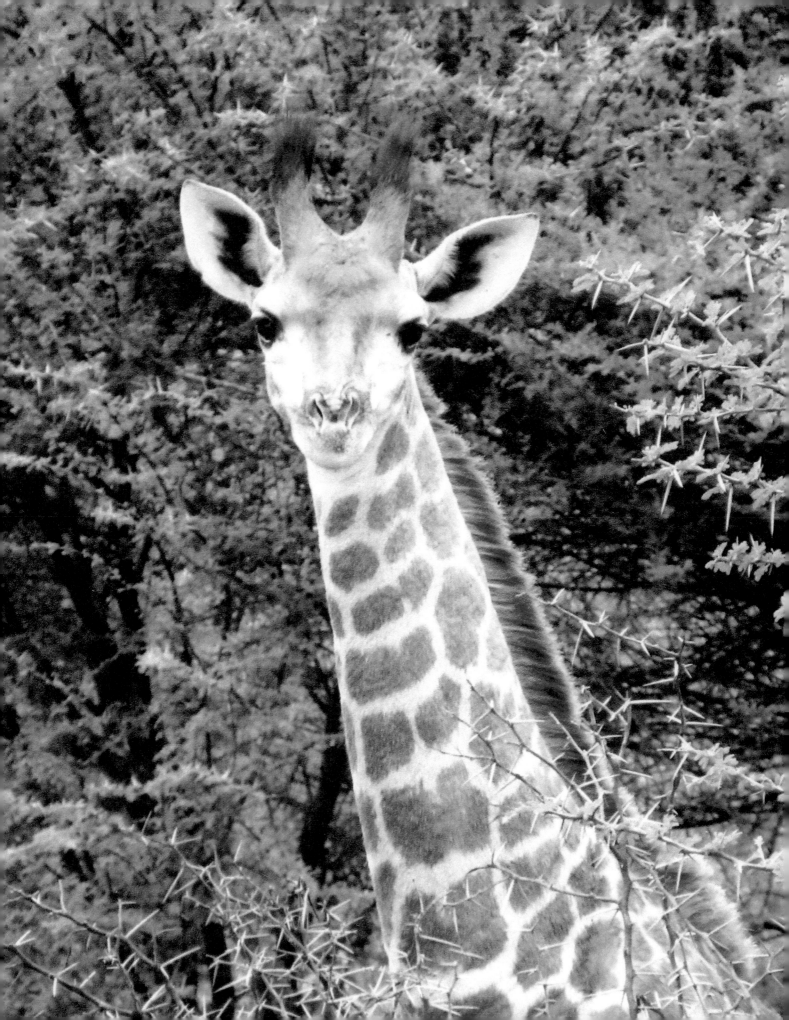

10. African Fish Eagle

The African Fish Eagle is also referred to as the "African Sea Eagle".

This bird is often found perched in the trees along the banks of rivers in Africa. There is a great concentration of the Fish Eagles along the Zambezi River.

In this location, they can establish a lookout point for fish swimming in the clear river water below. The Fish Eagles then swoop down to catch the fish.

This bird is also found in other parts of Africa such as Malawi, Namibia, Zimbabwe and Zambia.

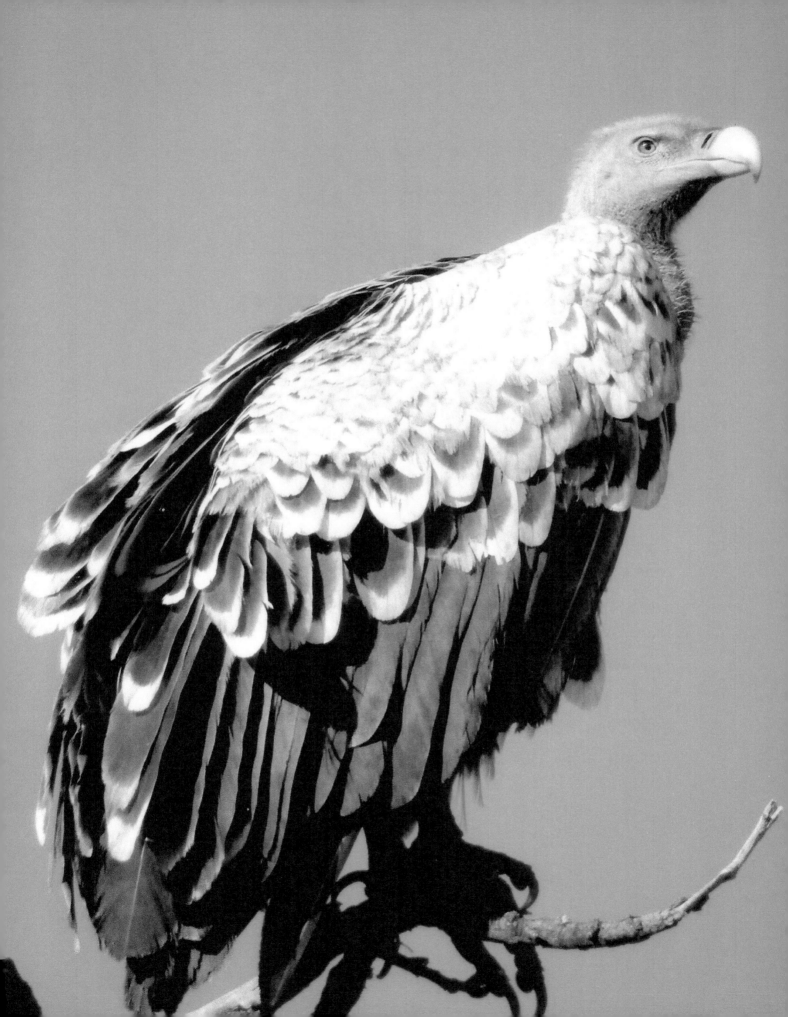

11. African Horned Owl

The African Horned Owl is also known as the "Spotted Eagle-Owl". Although only an average size owl, this owl is notable for its elongated ears.

From a distance, the ears noticeably protrude, giving the impression of two horns. There are actually about 32 different types of owls in Kenya alone which exhibit the prominent elongated ears.

There are also many variations of the coloring among these owls. These owls are categorized by many names including "African Grass Owl", "Long-Eared Owl", "Spot-Bellied Eagle Owl", "Great Horned Owls" and the "Cape Eagle Owls".

There is also another African long-eared owl called "Verreaux's Eagle Owl" which inhabits the Samburu National Park in Kenya. It is also known as the "Spotted Eagle-Owl". It is one of the world's smallest owls, and one of the most common species found in South Africa.

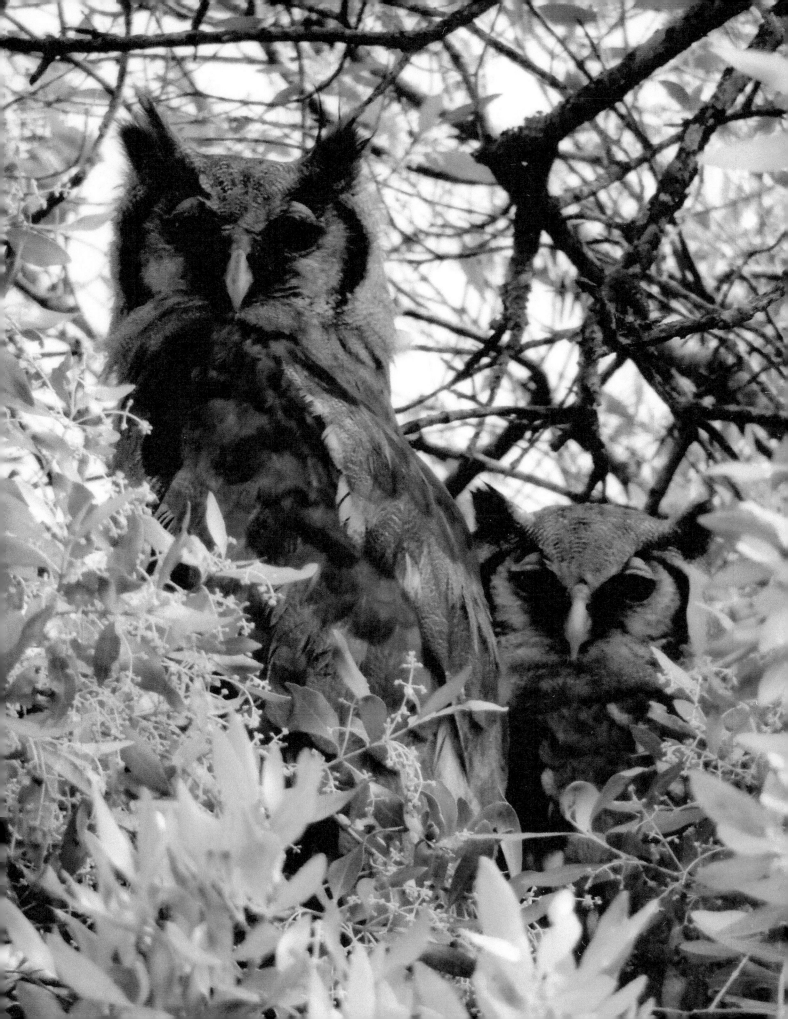

12. Hippopotamus and Mate

The hippopotamus is found in Kenya, with its extensive river system, as well as in several other parts of Africa. The greatest concentration of these animals is found in the Okavango Delta region in Botswana, near the Chobe River.

The hippopotamus is also found in neighboring Tanzania and near the Ngorogoro Crater.

The hippopotamus is called a "semi-aquatic" animal, because it can thrive on both land and water.

These animals can grow to enormous size, and are usually found near lakes and rivers. They immerse themselves in the cool water to escape the hot temperatures of the African sun.

A full grown female hippopotamus can weigh as much as 3,000 pounds. However, a male hippo can reach a weight of 5,000 pounds.

The white bird, often seen riding on the back of a hippo, is called a "cattle egret".

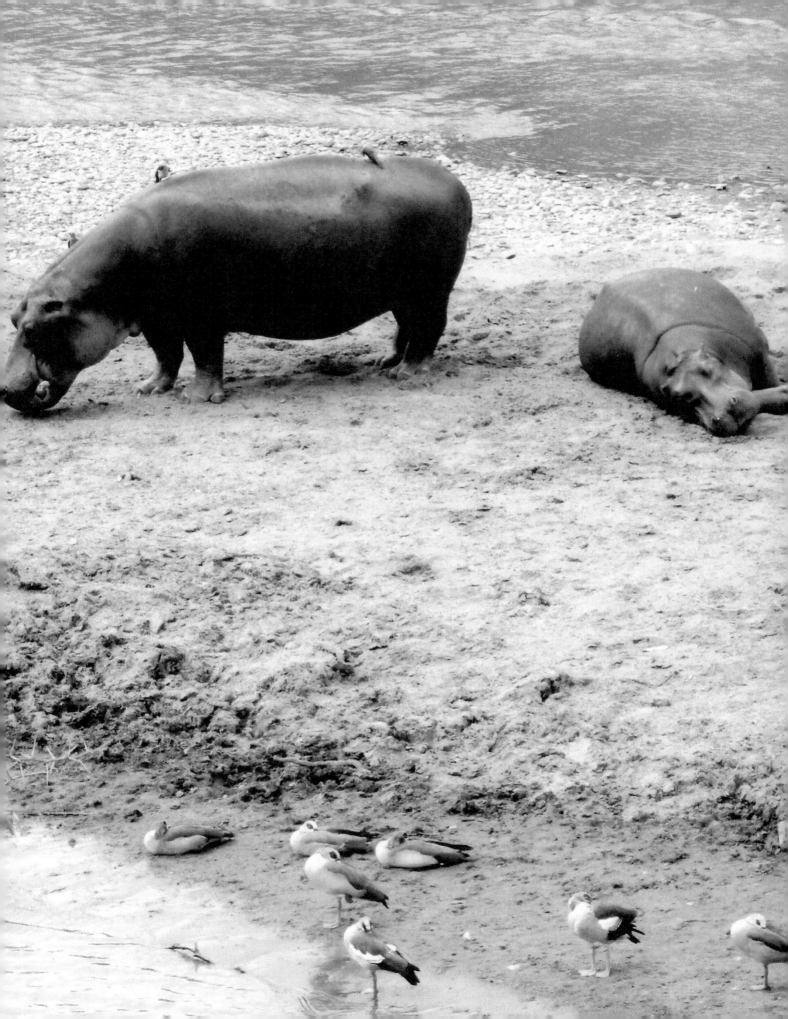

13. A Lake Full of Hippos

When very heavy seasonal rain occurs, the floodwaters fill the valleys of Kenya. Families of hippos congregate near these rivers.

This is one of the best times of the year to observe the hippopotamus.

The large hippos gather together in the spacious pools of water that come from the heavy seasonal rain. At that time, the hippos can be observed swimming by the hundreds in the vast expanse of water.

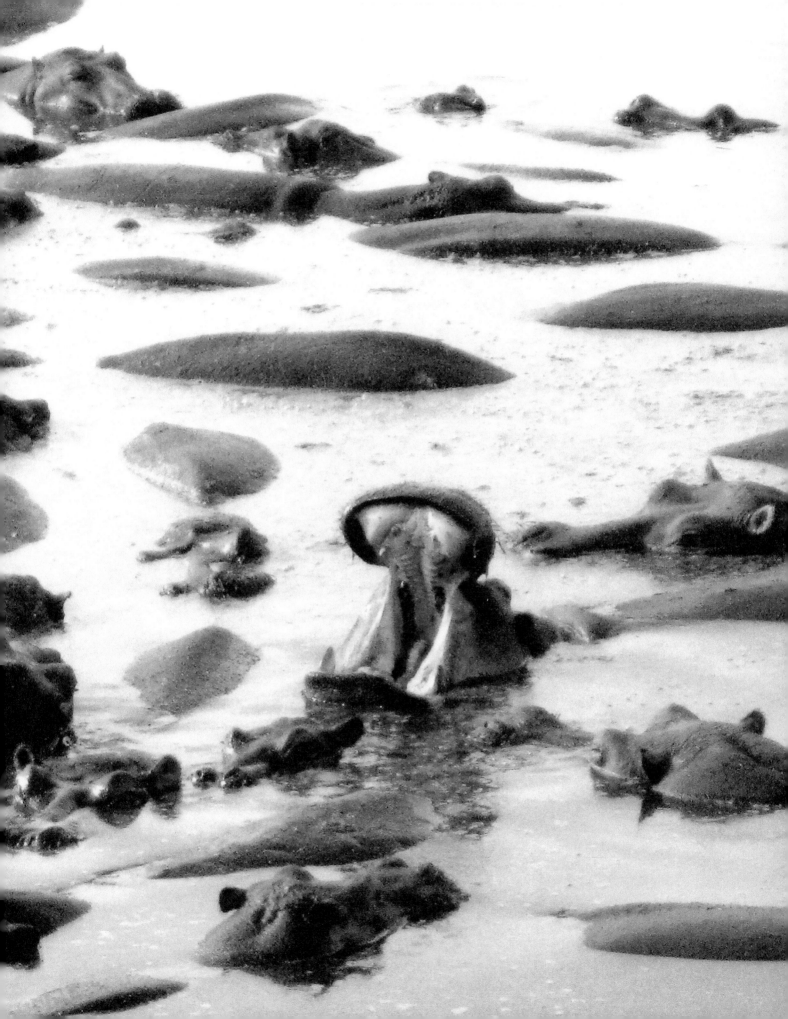

14. Elephant in the River

Kenya has several excellent reserves for elephants such as the Maasai Mara, Tsavo East, and the Amboseli National Park. The African Bush elephant, which occupies the Savanna, is the largest land animal on earth. In the early 1970's, Kenya banned elephant hunting and the ivory trade. Most people do not realize that among African elephants, both males and females have tusks. In one recent year in Africa, almost 400 elephants were lost to poachers, usually killing them for their ivory tusks. Today, fewer than half a million elephants live in all of Africa.

African elephants can reach a height of 11 feet, and live for almost seventy years. An elephant can eat over 250 pounds of food in one day. Elephants spend more than half their day eating, in order to replenish their large bodies.

Among these herds of the world's largest land animal, they are generally led by the older female matriarchs.

Surprisingly, it is documented that elephants usually have an instinctive fear of bees.

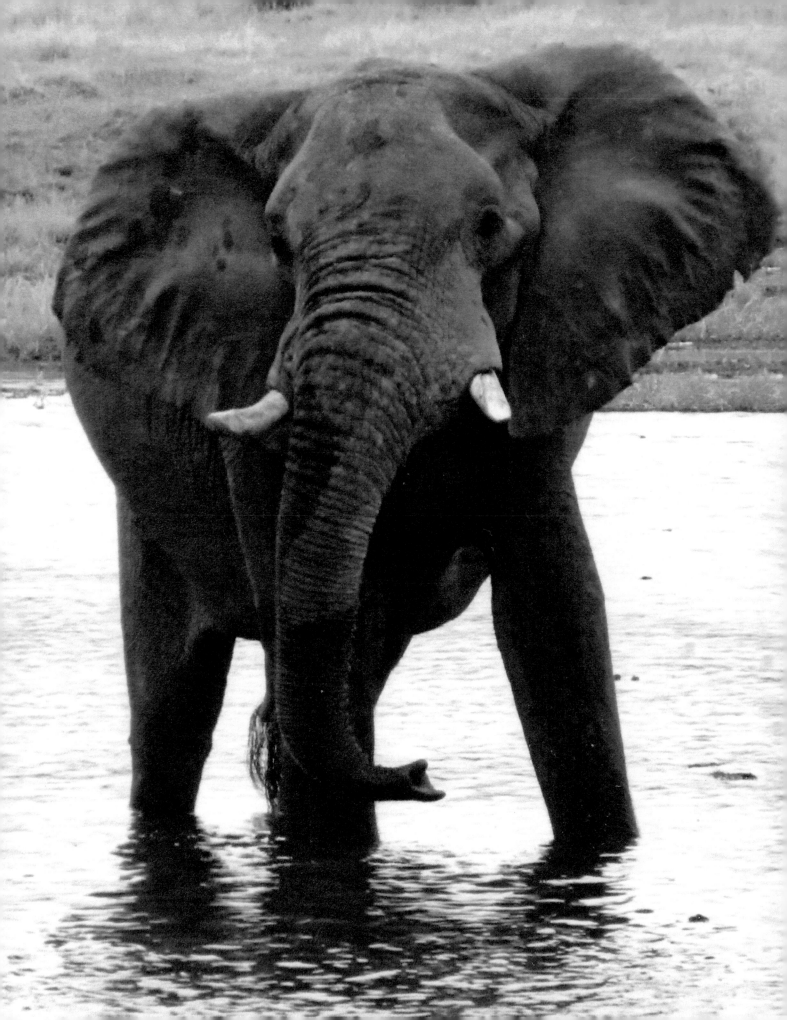

15. The Elephant Family

Some people believe that elephants mate for a lifetime. When a female elephant is pregnant, it takes almost two years for the baby elephant to be born. Elephants are able to stand within an hour after birth. They are able to walk within their first few days. Females and young elephants travel together in herds. Adult males travel alone, or in males-only groups.

Elephants are believed to have emotions and feelings more complex than other animals. Many people also believe that an elephant has a strong sense of loyalty. They also credit elephants with an ability to remember a long past kindness, or to remember a friend—elephant or human—after a long absence. Some have suggested that this is because the temporal lobe in the elephant's brain is significantly larger, and therefore enhances his ability to recall incidents from the past.

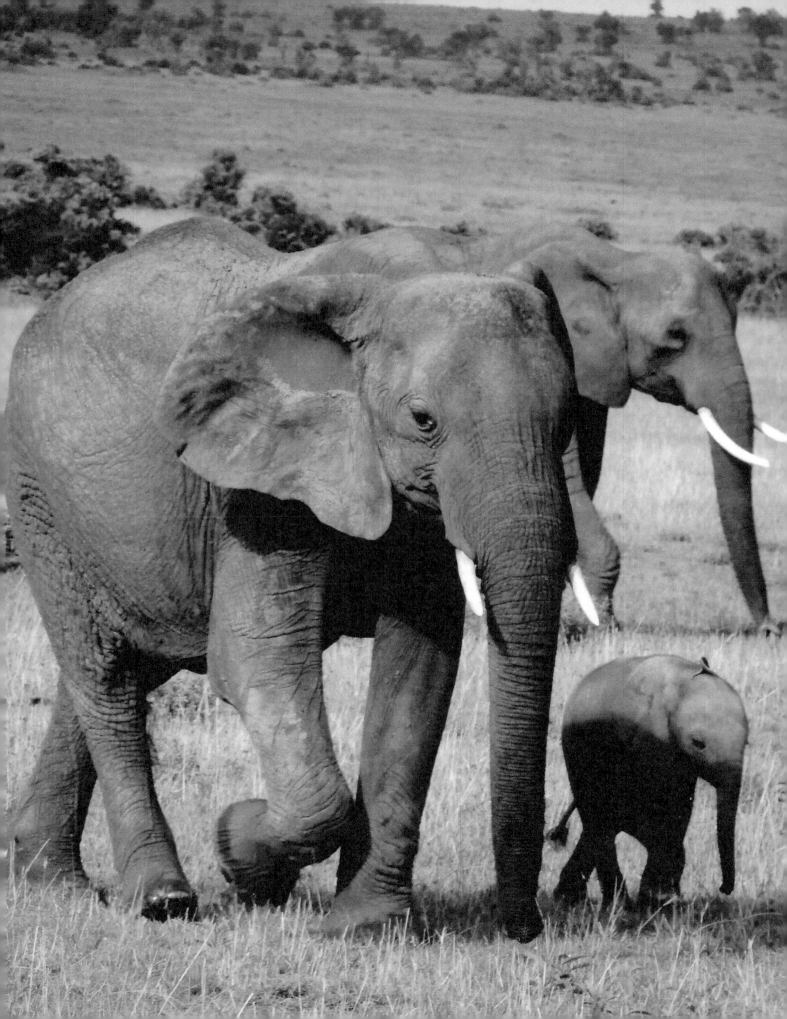

16. Two Oryx

The Oryx is an antelope with long pointed horns. It is a large antelope native to Africa and the Middle East.

Four related sub-species have been identified. Two of them, the "Scimitar" Horned Oryx and the "Arabian Oryx", are today almost extinct in the wild. Small populations live in protective captivity from hunting.

Unlike many other animal groups, the long and graceful horns are present in both the female and the male.

The existing Oryx today is also called the "Gemsbok". It is a rare antelope almost exclusively found in Africa. This very rare Oryx stands about five feet at the shoulder. This does not count the elongated horns which add another three feet in height. Their horns, when used to defend against attackers, have been lethal enough to kill lions.

The Oryx gravitated to hot climates where they adapt easily. These vegetarian animals live on plants, fruits and grass.

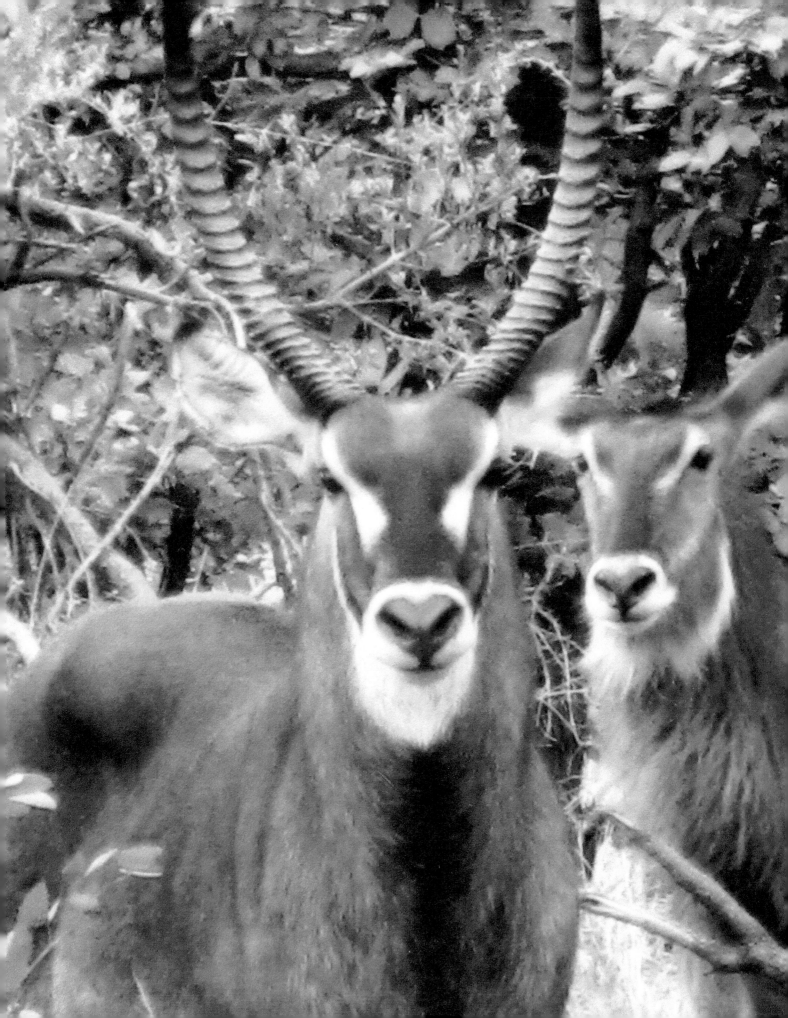

17. Rhinoceros near a Lake

The Black Rhinoceros is a rare and endangered species. It is found in Kenya and also in southern Africa. There is a large population of this rare animal in the Nairobi National Park.

The "Black Rhinoceros" is actually a medium brown, but may glisten a sleek black color when it emerges from the water. The "White Rhinoceros" is usually a slightly lighter brown in color. A Rhino can weigh over three tons in adulthood.

The Rhinoceros often takes "mud baths" in order to keep itself cool in the jungle heat. The mud also leaves a film on the elephant's skin which helps to repel insects which commonly follow elephant herds and bite them.

The rhinoceros is often killed for its horns. These animals are being hunted, almost to extinction, by those who put a bounty on their tusks. In some Asian cultures, the tusk of the rhinoceros is ground up to be used in medicines. Their numbers are now being drastically diminished worldwide.

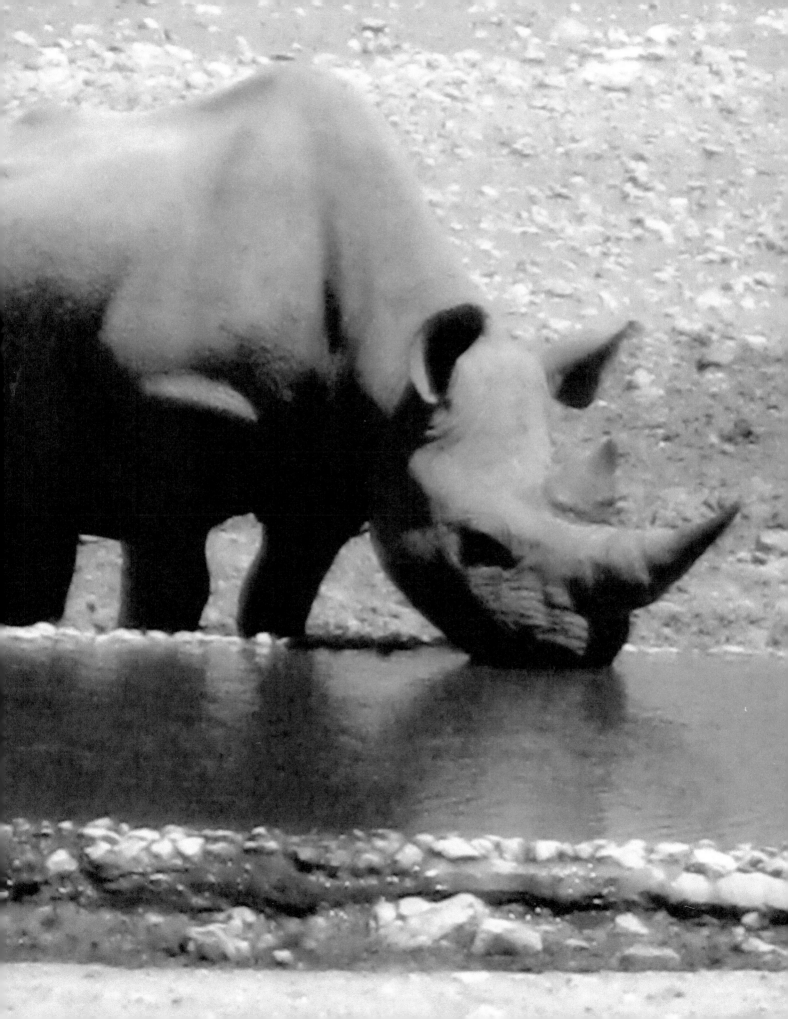

18. Crocodile Basks in Lake

The Nile Crocodile of Kenya is a surprisingly powerful animal.—significantly stronger and larger than the alligator. It prefers marshy water, while alligators choose to live in fresh water. The largest reptiles on earth, they can live to be over 60 years old.

People sometimes confuse crocodiles with alligators. Alligators live primarily in parts of North and South America. The significantly larger crocodiles, however, are found primarily in Africa and Asia. Crocodiles have elongated snouts, with a V-shape, unlike alligators with their short rounded snouts.

Female crocodiles lay about 50 eggs at one time. These eggs are incubated for 3 months in a large enclosed nest. When the offspring are ready to live on their own, the mother helps the new babies to break the outer shells of the eggs.

To aid digestion, crocodiles sometimes swallow small stones to break down tough ingested food. They have even been known to climb trees in pursuit of their prey. Crocodiles are able to travel at 22 miles per hour.

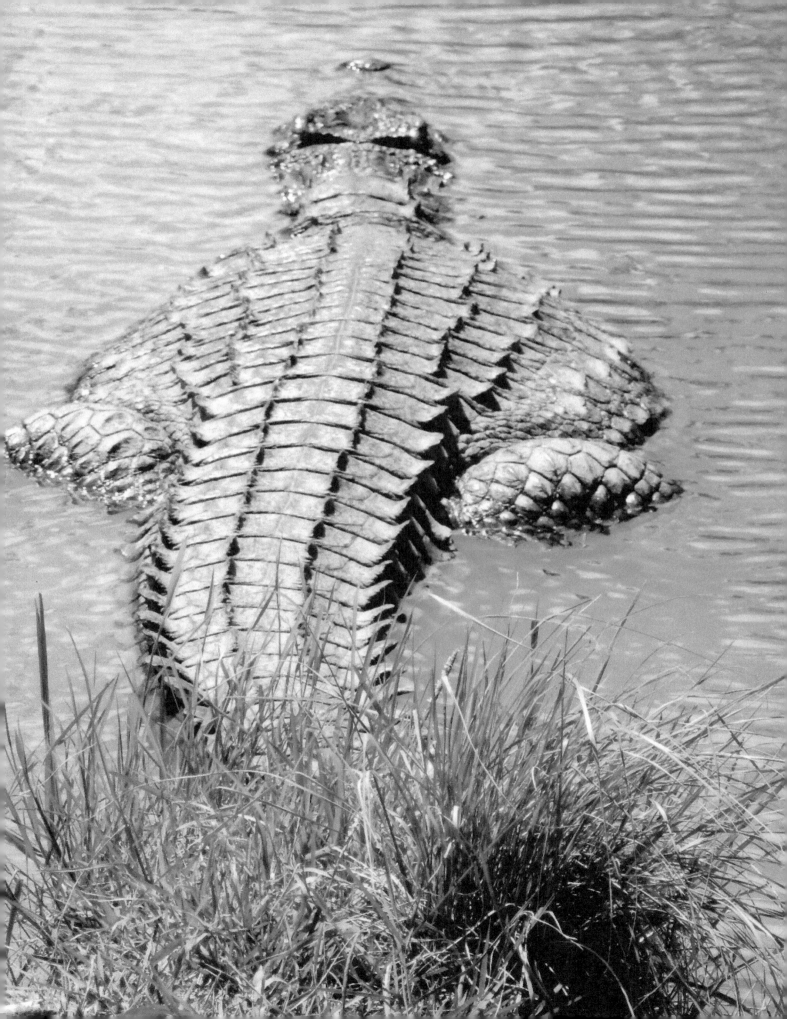

19. Egret Fishing for Breakfast

The Egret belongs to the "heron" family. It is found in wetlands in many parts of the world. In Kenya, egrets inhabit the regions along the country's expansive river system. American Indian tribes considered the Egret a sign of good fortune.

The wing span of the Egret can reach six feet across. The birds can reach a height of about four feet.

The primary food of the Egret is fish, but frogs and other small prey are also in their diet. The Egrets wade into marshes, ponds and streams to catch fish. They also include mice and grasshoppers in their diet.

When the Egrets breed, they build heavy nests in trees. The large nests measure about three feet across. Raccoons, hawks and owls will occasionally steal the young offspring out of the nests.

Egrets lay large, blue-green colored eggs. Surprisingly, newborns are able to fly within six weeks after birth.

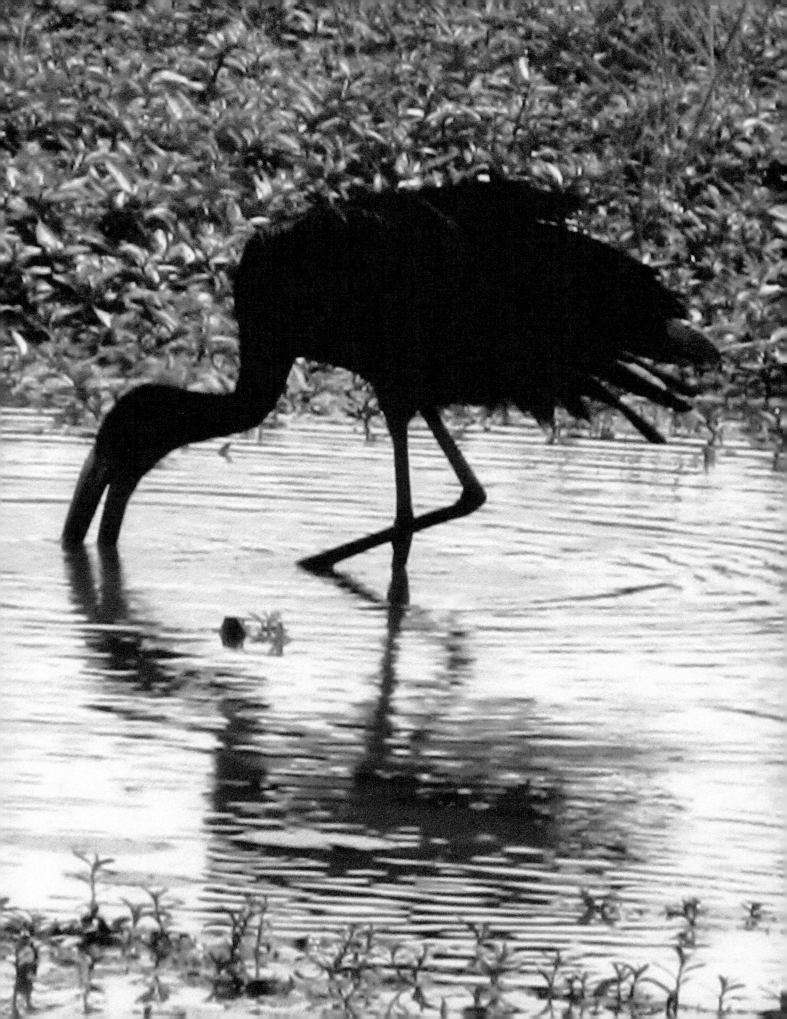

20. Baboon Sitting in Summer Grass

A number of baboons are found in Nairobi National Park in Kenya. The most common species in this area is the "Olive Baboon". Baboons inhabit vast areas. Their territories include woodlands, wilderness and savannas.

Baboons live in groups varying from six individuals to larger coalesced families. Sometimes these groups can include as many as a hundred individuals. Noisy squealing and cries can often accompany the active baboon population.

It is not unusual for baboons to come near tented tourist camps. They visit as much out of curiosity, as they do for food. It is estimated that over 6,000 baboons live in the wild outside of the established nature reserves in Kenya. They tend to carry off small animals and steal food on night raids.

Baboons, despite their size and strength, normally do not present a danger to tourists. Attacks on humans are rare. Challenging circumstances may lead to baboons forming much larger groups of 50 to 100 individuals in order to ensure their own safety and well-being.

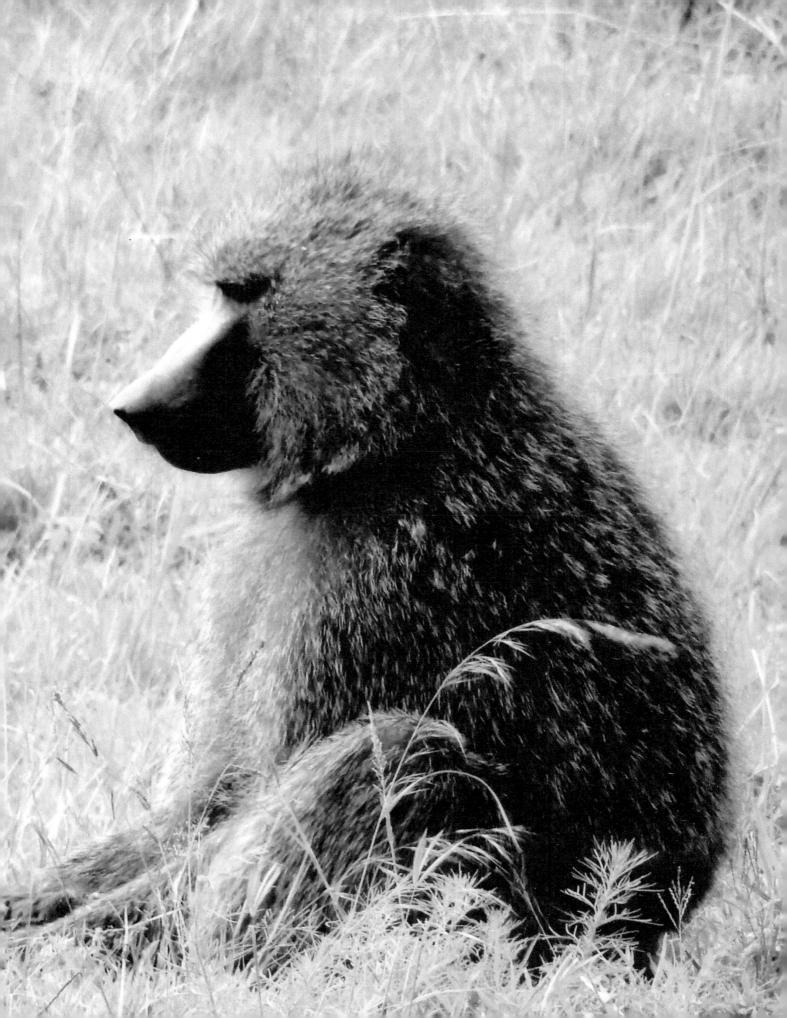

21. African Cape Buffalo

The large African Cape Buffalo is also known as the "African Horned Buffalo". It is common in Kenya's Lake Nakuru region, and also near Tanzania's Ngorongoro Crater.

The massive frame of the African Buffalo is daunting to its enemies. Its body length can reach over ten feet, and males can weigh up to 2,000 pounds. Their herds can number as many as 1,800 animals. Despite their great size, they do not eat other animals. They eat a strictly plant-based diet.

Often visitors observe White Egrets or other birds riding on the backs of the Cape Buffalo. These birds have been given the unofficial name of "hitch-hiker" birds.

The Cape Buffalo is extremely dangerous, and is one of the few animals which can subdue and kill lions, charging toward them at speeds over 30 miles per hour. They are fearless in protecting their families.

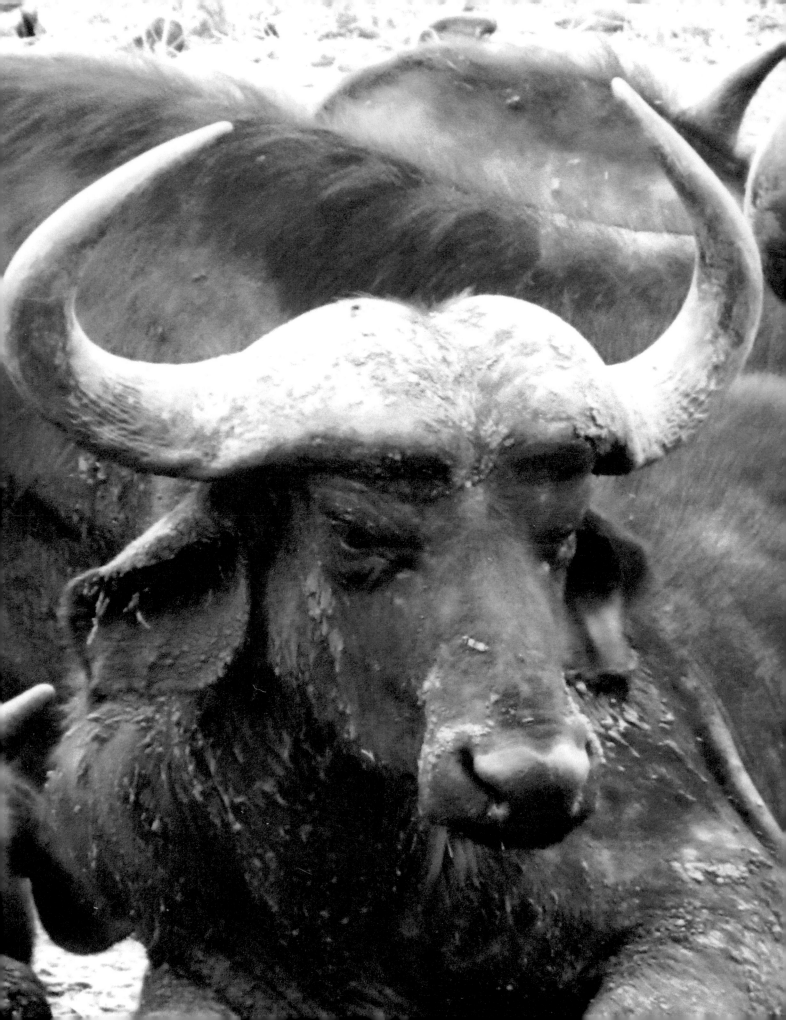

22. The World of the Zebra

A very popular spot for zebras is near the lake in Amboseli, Kenya. They are also very common in Kenya's many national parks and reserves, as well as other regions in Africa.

Despite the relatively short and slender legs of the zebras, their hard hooves can deliver a powerful blow to attackers. Their quick response to intruders and their powerful kick can injure predators as large as a lion. They can easily escape predators, with their ability to run almost sixty miles an hour when they are being pursued.

There are three types of zebra in Africa: Grevy's Zebra, the Plains Zebra and the Mountain Zebra. Grevy's Zebra is the most predominant type of zebra in Kenya. It can reach a weight as heavy as 980 pounds.

Every zebra has unique stripes in the same way all humans have individual fingerprints.

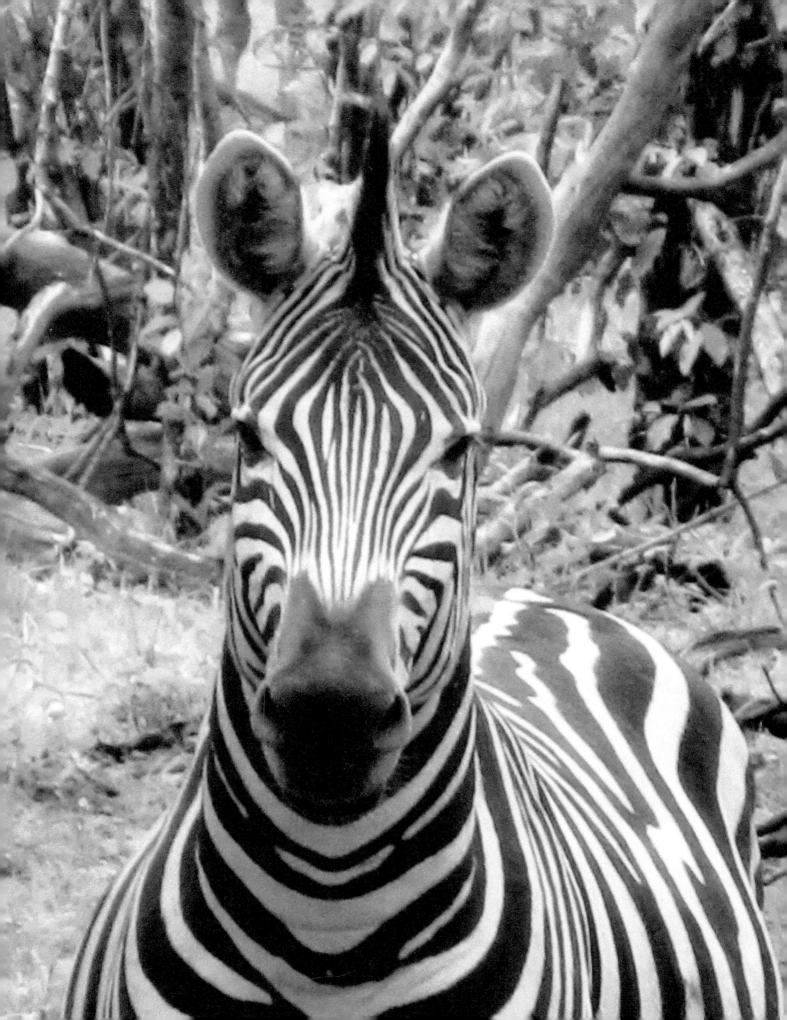

23. A Field of Zebras

One of the favorite gathering spots for zebras is near Lake Nakuru at the National Park in Kenya. It is a unique visual experience. The zebras, in their coming together, form a stunning design on the jungle landscape. It is a contemporary black and white collage on the rich and vibrant African landscape, coming to life in a living work of art.

One surprising fact is that within a few hours of birth, zebras are able to both stand and also to run.

The Zebra is also one of the few mammals able to see colors. They can see well both in daytime and at night. Also, they can sleep standing up.

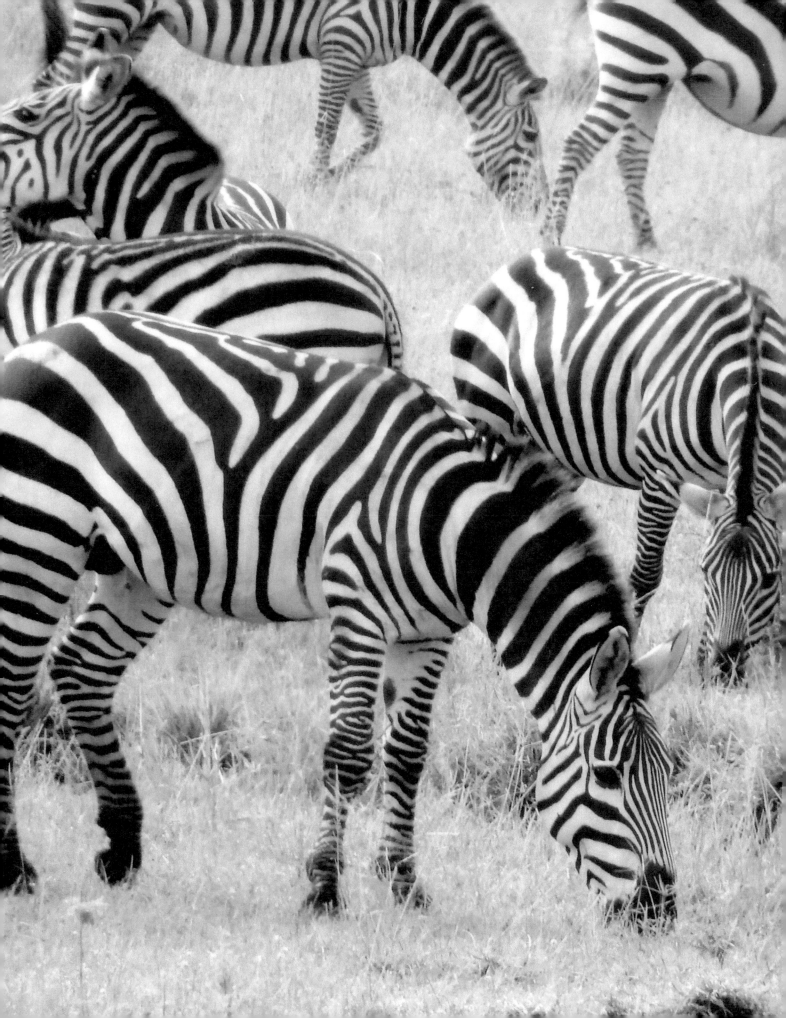

24. Cheetah Resting in the Bush

The Cheetah has the distinction of being the world's fastest animal on land. It can run 80 miles per hour. It has a sleek build, with strong thick legs. It is easily recognizable by the two distinctive perpendicular black lines on each side of its face. Roughly perpendicular, these lines extend from each eye down to the corners of the Cheetah's mouth.

A full-grown Cheetah weighs only about 130 pounds. Their strong and lean bodies are well adapted for running and hunting. Unlike many animals that hunt at night, the Cheetahs primarily hunt in the early morning hours and around dusk. Their keen eyesight allows them to see their prey at great distances.

Females can give birth to as many as six cubs at one time. Each cub weighs less than a pound a birth. New cubs are able to hunt when they are only six months old. A Cheetah's lifespan, normally about ten years, can be much longer in a zoo or in protected captivity. There are fewer than 6,000 cheetahs worldwide.

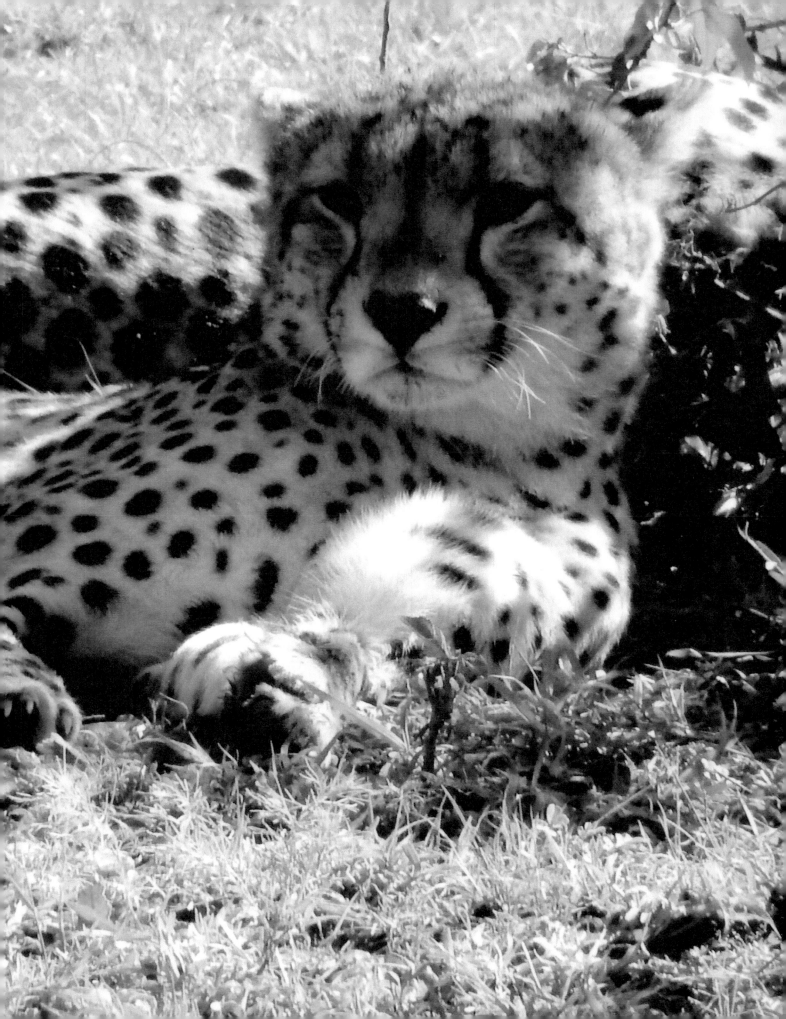

25. Leopard in a Tree

The Leopard is a sleek jungle cat recognizable by its prominent black and brown spots called "rosettes". It is one of Africa's most dangerous predators. A leopard can kill animals which have over three times his own body weight. He is considered the strongest of the African cats.

Leopards have an amazing ability to see in darkness that is almost ten times that of humans. They also have a keen sense of hearing well beyond the human range.

The average male leopard weighs about 70 pounds, with the female being about ten pounds lighter.

Leopards are daunting hunters. They carefully stalk their prey. As predators, they have the advantage of speed. They are able to run at over 36 miles per hour. Sometimes after killing their prey, leopards drag the remains up a tree to keep them out of the reach of other animals.

Surprisingly, leopards tend to be reclusive, and spend a great deal of time alone.

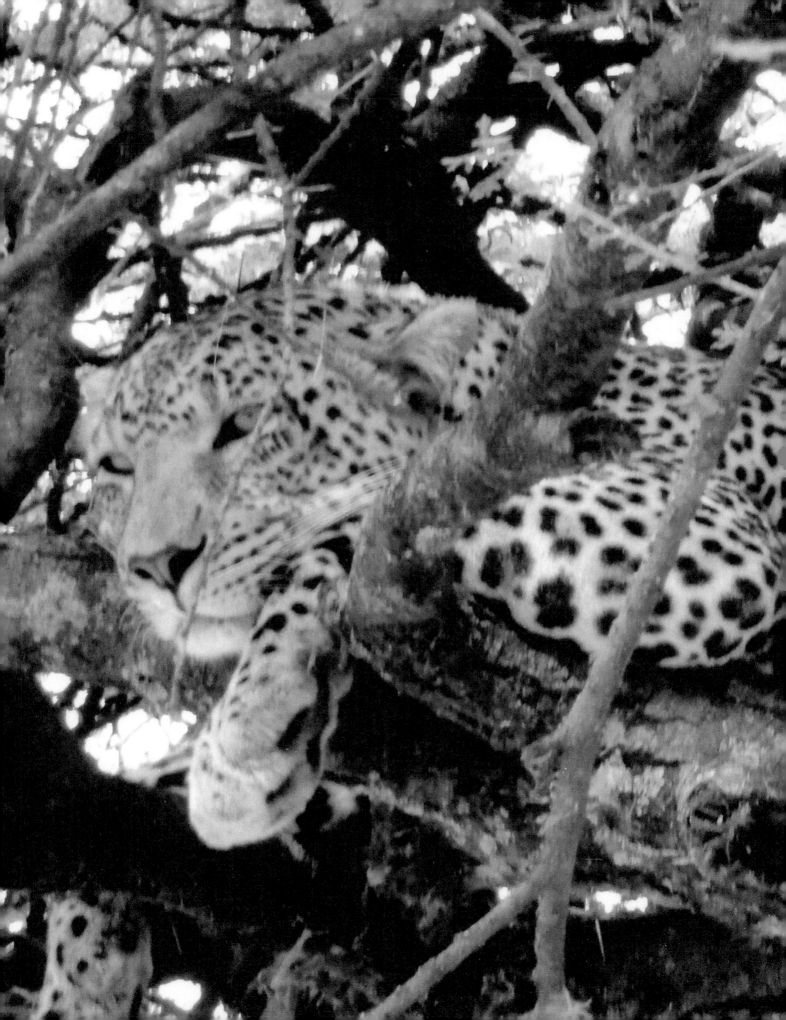

The End

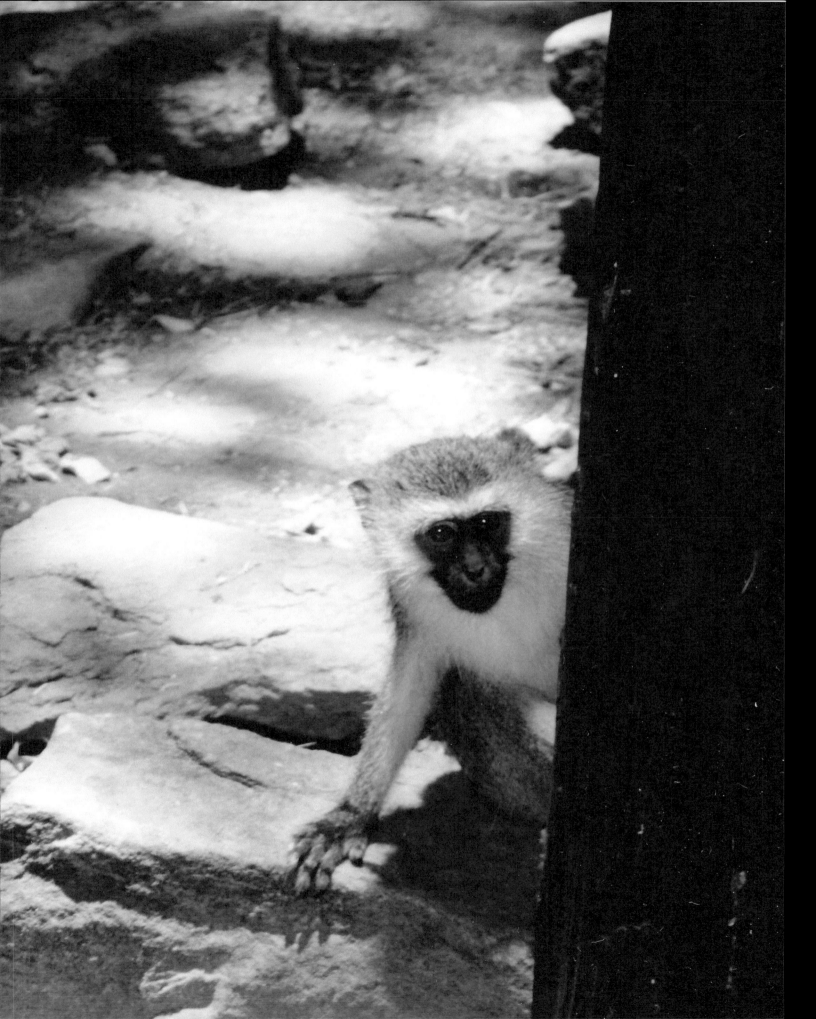

Printed in the United States
by Baker & Taylor Publisher Services